DAVID HORVATH AND SUN-MIN KIM

HOW TO DRAW

UGLYDOLL™

UGLY DRAWINGS IN A FEW EASY STEPS!

How?

DRAW THEM YOUR WAY!

Walter Foster

WHO ARE THE UGLYDOLLS?

So who are these Uglydolls?
What do they do? (Well, what do you do?)

The Uglydolls are there for us. They've got our backs when we're down, and they've got our snacks when we can't find them. When something happy takes place, you'll often have the Uglydolls to thank. And when something scary happens, you'll hear from them in a little while—after they've relocated.

But why "ugly"? What does UGLY mean? Ugly means unique! Ugly mean special! Anyone can be beautiful, but it takes originality and a lot of bravery to be yourself. Okay, so that's the "ugly." But what about the "doll"? Are they dolls? Be a DOLL and read the next page.

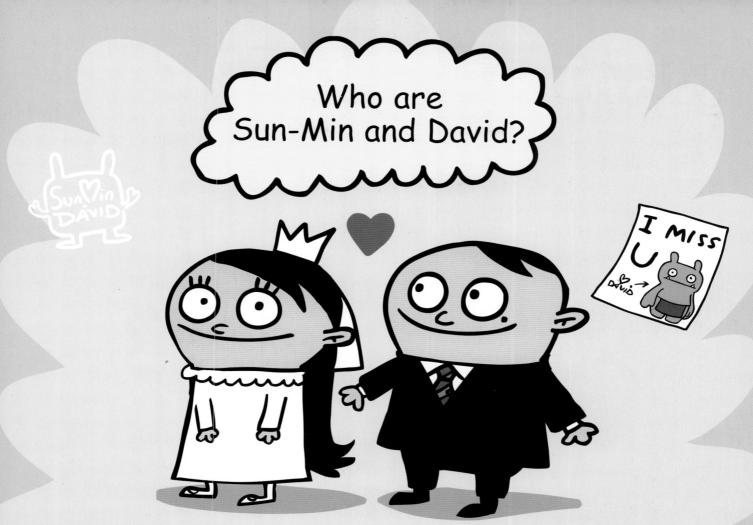

Who are Sun-Min and David?

I MISS U
David →

Sun-Min Kim and David Horvath are the inventors of the Uglydolls. (In fact, David created all of the ugly art in this book!) A long time ago, Sun-Min had to move to Korea, and this made David very sad. So David wrote many mushy "I miss you" letters to Sun-Min and drew a little WAGE character at the bottom of the page.

Sun-Min turned the drawing into a doll as a gift for David, and together they created a product called "UGLYDOLL."
Now Sun-Min and David are married and spend all of their time making the "UGLY-EST" art the world has ever seen!

MAIL

to:
From

THIS SIDE BROKEN

WHAT DO I NEED?

Well, you don't need an eraser because there are no mistakes! David Horvath (the fellow who made this book) never uses an eraser (but maybe he should!). The point is that there's no such thing as a mistake when you're using your . . .

AN ERASER?? WHA???

. . . IMAGINATION! Don't just follow the rules in this book! (You may not even find any.) If you feel like drawing the characters in a certain way, go for it! If the book tells you to make three eyes and you want to make 100 eyes, PERFECT! That's what UGLY is all about!

IMAGINATION

Markers are fun to use, but make sure you stay on the paper. Marker ink on your clothes or on the sofa or wall is sort of difficult to wash off. And don't put markers too close to your nose (not even the smelly ones).

SMELLY INK

MARKERS

Paper helps a lot. You can use any kind of paper to draw your UGLYS, even a brown paper bag. When you're practicing, try using both sides of the paper so you don't waste it. And don't throw out your art! All art is precious and should never be thrown away. (But recycling is okay if you really can't stand one of your drawings.)

PAPER

CRAYONS

Crayons are great for drawing Uglydolls! If you press kind of hard, you can make outlines. And if you color using a softer touch, you can . . . color!

COLORED PENCILS

Colored pencils are a lot of fun—except for the white one. What's up with that? Maybe it's for drawing on purple paper?!

HOW TO USE THIS BOOK

IT'S EASY!

PLEASE NOTE!!!!

This book is just a guide. How an artist draws something is always up to the artist. It may be fun to draw the Uglydolls as they really appear, but using your own imagination will always add something special!

1

STEP ONE

See how the eyes are blue? They're blue because they're new. But they'll be black in the next step because something else will be new—and blue. Get it? (Just draw whatever is blue in each step.)

2

STEP TWO

See? Now the mouth is blue because it was added after the eyes. So in step three, the body would be blue, and the eyes and mouth would all be shown in black.

OH, AND, ALSO . . .

What makes a good drawing? Is a drawing that looks super realistic a good drawing? Maybe. Who knows? Many of the world's great artists draw trees that look like funny shapes and blobs! A good drawing is a good drawing when you say it's a good drawing. (So there!)

UGLY SIZE CHART

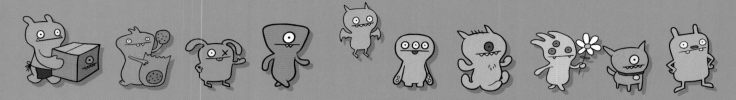

Some Uglys are two heads tall, some three heads tall, and some two-and-a-half heads tall. (You can't get much uglier than half a head!) You can draw them like this—or you can pretend that you never saw this page.

WAGE™

Wage is a hard worker. (Just like you!) He wears his apron to serve his customers best. Usually his one and only customer is his best pal, Babo . . . but there's always room for one more—YOU!

1

EYES

To draw Wage's eyeballs, do your best to draw two perfect circles. Didn't come out so perfect? PERFECT! Now put little dots in the centers.

2

MOUTH

All Uglydolls have a straight line for a mouth. Or pretty straight. (Ugly straight?) Keep the mouth close to Wage's eyes, and add little triangle teeth. (They point up!)

3

BODY

Wage's body doesn't have any sharp edges (except his teeth!). Draw his body, legs, head, and arms all at once! Wage's hands look like lobster claws, and he doesn't really have feet . . . unless you give him some.

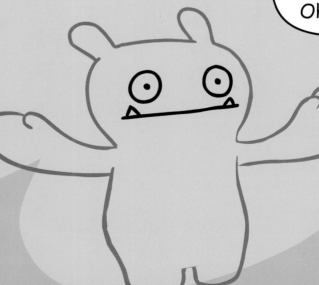

My mouth is too low! Oh, well.

4 APRON

All hard workers have aprons, right? Well, so does Wage! From the front, Wage's apron looks like an upside-down hat. Sort of.

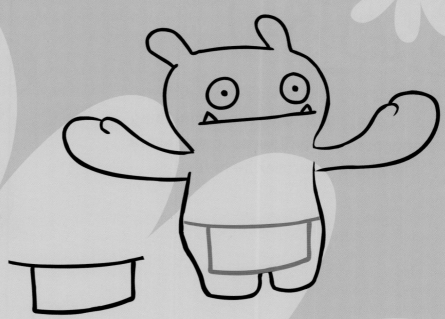

5 COLOR

Time to color! Use crayons, colored pencils, or markers to fill in Wage's lovely Ugly fur and apron. Don't have orange? Use blue and pretend Wage is working the night shift.

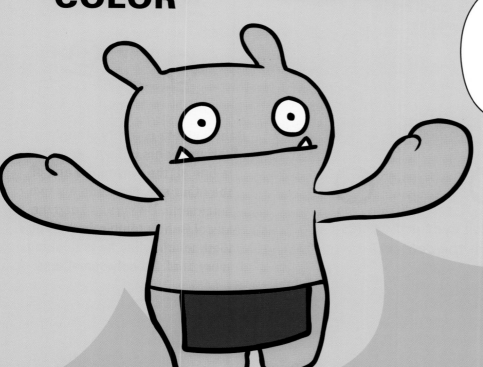

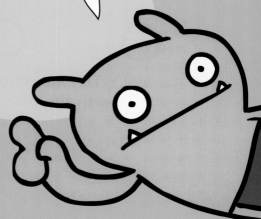

Step 6: Forget steps 1 through 5 and draw me any way you'd like!

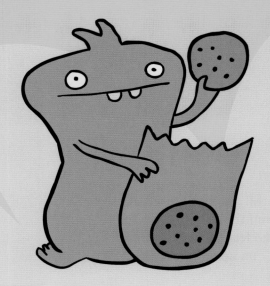

Babo's got your back! He's always there for you. Count on it! And when something scary happens, he will write to you every day from wherever he hides.

1
EYES

To draw Babo's eyes, do your best to draw two perfect circles. Babo's eyes are a tiny bit smaller than Wage's eyes. All Uglydolls have a little round dot in the center of their eyeballs.

2
MOUTH

Babo's mouth is a very straight line. Start under his left eye, and draw a line all the way to the end of the other eye. Now add his two buckteeth. Be sure to keep the ends of Babo's teeth round. Babo's teeth touch when he is thinking very hard. So only sometimes.

UGLY TIP! All Uglydoll eyes are circles with tiny dots in the center.

3

BODY

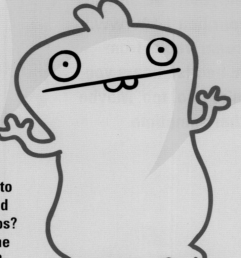

Babo is very round. He doesn't have many edges or corners. Try to draw Babo's head, feet, body, and arms all at once! See Babo's lumps? They tend to wave, like hair in the wind. Is that hair? Who knows? Wave back anyway.

Babo has three toes on each foot, and two hands in the cookie jar.

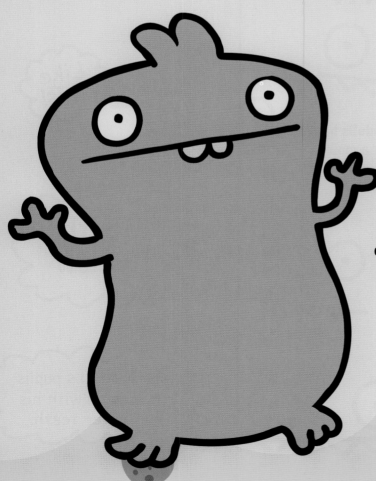

4

COLOR

How do you color Babo? With a lot of blue! His body is blue, his teeth are light blue, his eyes are yellow, and his snacks have run out. Please draw all new ones.

ICE-BAT ™

Ice-Bat lives in an icebox. Everything he touches turns to ice, yet he warms your heart. (Awww.) His large ears hear ice cream trucks from miles away. What's that? Oh, he also hears you think he's cool. He thinks you're cool too. Maybe you can chill out together sometime.

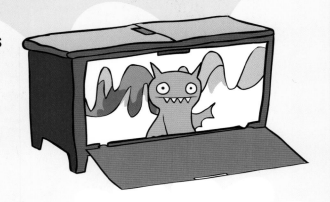

Try drawing Ice-Bat inside his icebox. Simply draw him from the waist up to show him peeking out to say "hi" or "bye."

EYES

To draw Ice-Bat's eyeballs, make two circles as round as you can, and place some tiny pupils right in the center.

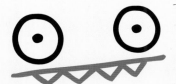

MOUTH

You know all Uglydolls have a straight line for a mouth, but you might be wondering why. No one knows. Anyway . . .

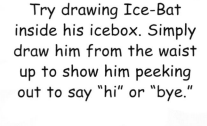

Like this!

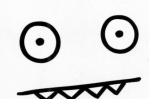

Mouth too low

NOW THAT'S UGLY!

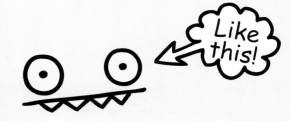

Ice-Bat's pupils line up with his outer teeth.

3 HEAD

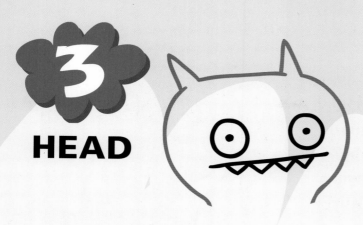

Wanna know what the trick to making a great Uglydoll head is? Try drawing it all at once! Ice-Bat has two pointy ears at the top of his head. See how one ear points straight up and his other ear points at an angle? You can draw them that way. Or not.

4 BODY & WINGS

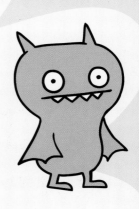

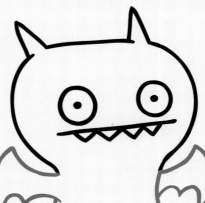

If your Ice-Bat is going to fly, point his toes down and his wings up. If he's going to stand, draw his feet flat and his wings down.

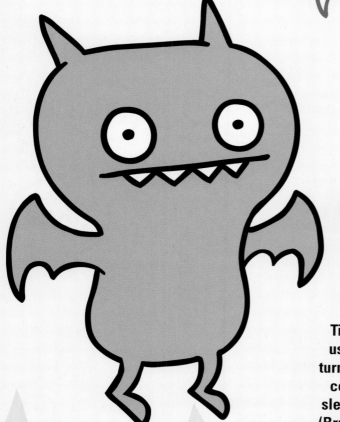

5 COLOR

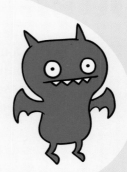

Time to color! Ice-Bat is usually light blue, but he turns red when he loses his cool and white when he sleeps in his chilly icebox. (Brrr.) Ice-Bat also glows in the dark when it's REALLY cold out—but do they make crayons that glow?

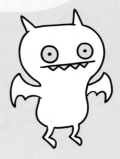

JEERO™

Jeero doesn't know. What time is it? Don't know. How many? No idea. Why, why, why? Dunno, Dunno, Dunno. When Jeero's not saying, "I don't know," he's working out. ONE . . . DONE! Time for a cupcake. See? Just like you.

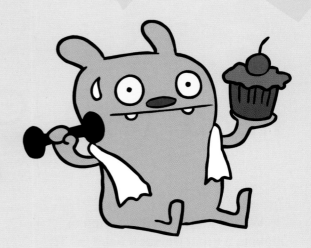

1

EYES

When drawing Jeero's eyes, keep in mind that you need room for his nose, which will sit between each eyeball.

2

NOSE & MOUTH

Jeero is the first Uglydoll to have a nose, so keep in mind the space between his eyes and nose and his nose and mouth. Notice that Jeero's eyes are right above his two teeth.

3

Jeero's ears point back just a little bit—and it's okay to make one of his ears larger than the other. This happens when Jeero is listening to you (which doesn't happen very often . . . but still).

HEAD

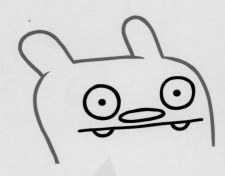

BODY

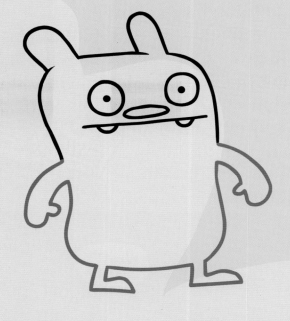

Jeero's body looks a lot like his head drawn upside down. And here's a hint about his feet: If you can draw Ice-Bat's feet, you can draw Jeero's. (They even have the same shoe size—none!)

5

COLOR

Jeero could use a little color. His nose is very dark red, but if you don't have dark red, you can use regular red and just draw a tissue in Jeero's hand. You might want to add some soap in his other hand so he doesn't spread germs!

VERY MACHO →

Jeero's pose should be very macho. Is Jeero a tough guy? No. He just looks that way because of all the ice cream. He calls it his "MACHO STANCE"!

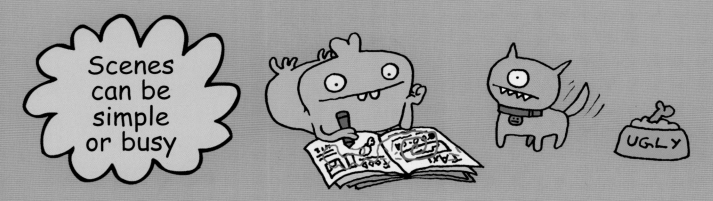

Scenes can be simple or busy

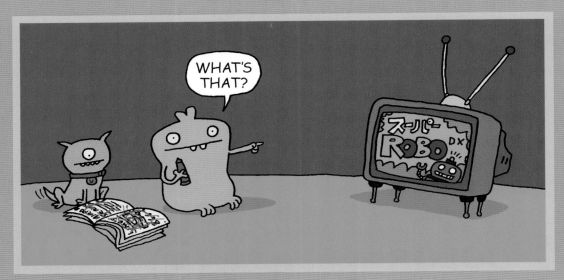

Here's a simple scene: See Babo watch the TV while Uglydog "reads"? See? Simple!

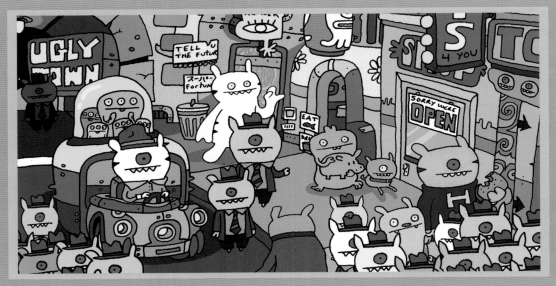

Scenes can also be busy. This street is so busy, it's hard to see Babo and Uglydog. Where's Babo? (Wait, that's another book.)

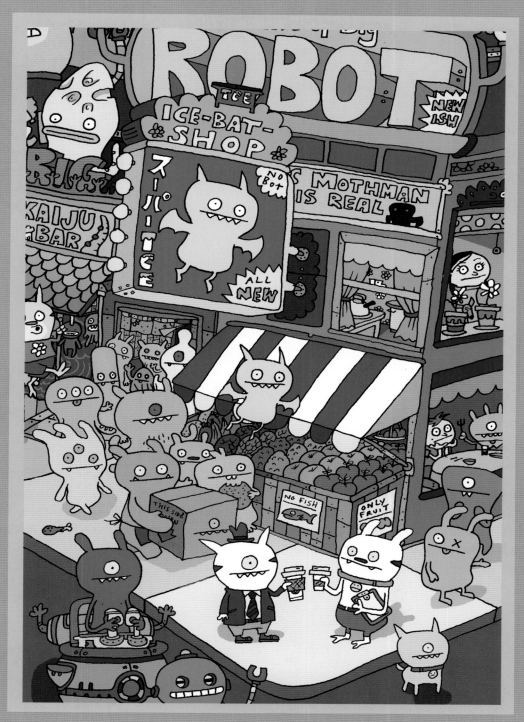

You can draw an ugly scene of any place. At home. On the street. Even in the sky, if Ice-Bat's around. Try putting all the Uglys in one scene. Or just draw them one by one. It doesn't really matter.

Let's DRAW Some UGLY ART

TARGET ™

Target is the oldest Uglydoll. That's why he has hair. Target thinks that having hair means that he's a smarty. So he's constantly trying to come up with ways to grow more. No luck so far.

1

EYE

Target has one eye, so this is an easy start. Draw a circle, and place a little dot in the center. It doesn't have to be a perfect circle— a round one will do just fine!

2

MOUTH

As you know by now, all Uglydolls have a straight line for a mouth. If you can draw Ice-Bat's mouth, Target's will be a breeze. Try to keep the mouth close to the eyeball!

3

HEAD

Target's head and Ice-Bat's head seem to be quite similar. See Target's ears? When Target is stressed out, they point back a little. (He must be stressed because you haven't added his hair yet.)

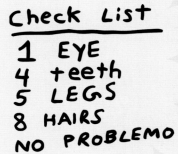

Check List
1 EYE
4 teeth
5 LEGS
8 HAIRS
NO PROBLEMO

 HAIR

Next comes Target's hair! Target has a lot of little hairs on his head, but when they are neatly combed, we can see only four of them at a time.

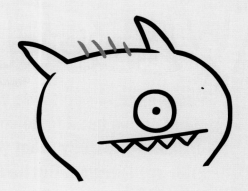

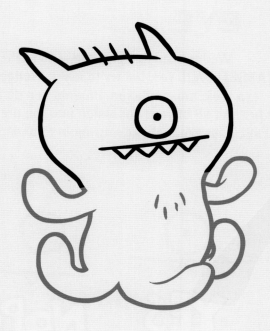

 BODY

Target has five legs—or two arms and three legs, depending on how you look at it. Target also has four more little hairs on his chest, right above his tummy. Target thinks every hair counts, so he'd like you to count every hair. But you can do whatever you want.

 COLOR

Target has a bright red eye and four slightly yellow teeth. His hair is black, and his skin is the same color as Cinko's. But if you want to make him green or pink, go right ahead. We won't tell.

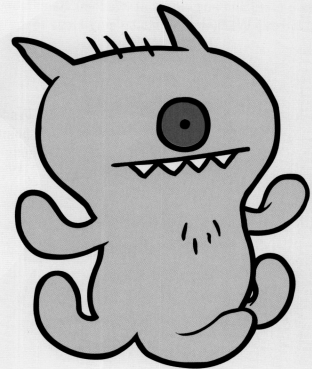

WEDGEHEAD™

Wedgehead understands you. He has to stand on his head to do so . . . but still, he knows exactly what you mean. Poor Wedgehead. But he'll be okay.

1 EYE

Wedgehead has one eye, JUST LIKE TARGET! Well, yes, but try to make Wedgehead's eye look, um, confused. How do you do that? Just put all of your confusion into the drawing. FEEL poor Wedgehead's struggle to understand.

2 MOUTH

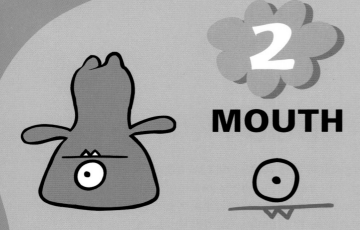

Wedgehead has two pointy teeth sticking down from his very straight mouth. Wedgehead's mouth is just like Target's and Ice-Bat's (minus two teeth and any words of wisdom). Remember to keep Wedgehead's mouth very close to the bottom of his eye.

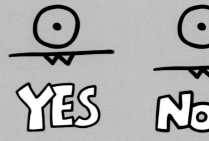

3 HEAD & ARM

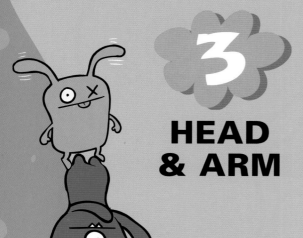

Wedgehead has a . . . wedge head. Imagine a slice of pizza pointing down, but the pointy part has been eaten. (Getting hungry?) Now add an arm coming up to Wedgehead's mouth. Why the arm? To express doubt? Deep thought? An itch?

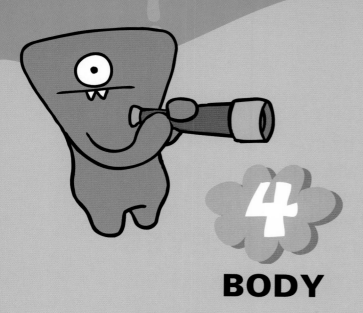

4 BODY

Wedgehead has very short legs ending in stumps, and his tummy sticks out just a little. His hands are round at the ends . . . no fingers for Wedgehead. That's okay. He can count all of his great ideas on one hand!

Look, I'm invisible!

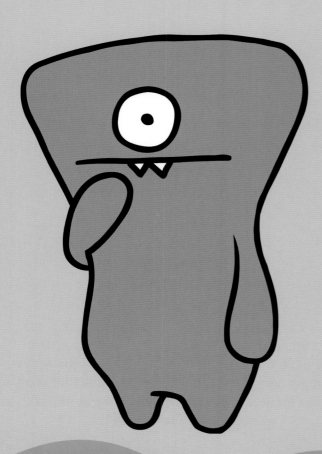

All your art belongs to us

5 COLOR

Wedgehead's eye is white, so if you're drawing on white paper, you won't need to use the white crayon, which never really works anyway. His body is blue, from head to toe—uh, leg.

OX

OX! As in hug and kiss, not the animal. OX likes bags of money. He also likes bags filled with items you used to own. OX and Wedgehead travel the globe together in search of other stuff you may have somewhere. Wanna help them out?

1 EYES

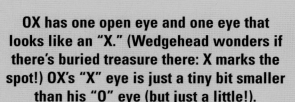

OX has one open eye and one eye that looks like an "X." (Wedgehead wonders if there's buried treasure there: X marks the spot!) OX's "X" eye is just a tiny bit smaller than his "O" eye (but just a little!).

2 MOUTH

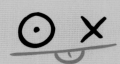

OX's mouth is a very straight line. Don't use a ruler to make the line, though! Always draw Uglydolls freehand. It's okay if the line is a little wiggly. Oh, and don't forget the tongue. OX's tongue is a half-circle with a line down the center.

3 HEAD

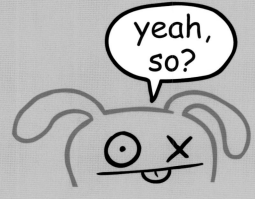

yeah, so?

OX's ears droop down like a puppy dog's. He can use them as wings for flight, so they flap around quite a bit. Does one of OX's ears look a little longer than the other ear? That's okay. Just don't let them pass the line of his mouth. (Unless you REALLY want them to. That's okay too.)

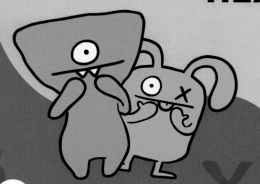

4 BODY

OX has a very short body. His arms are similar to Jeero's—but a lot smaller. OX's feet usually point in the same direction. Why? Not sure, really. Actually, ALL of the Uglydolls' feet point in the same direction. (Well, the ones who have feet, anyway.) See that picture of OX with Wedgehead? His feet are pointing in opposite directions! That's because OX breaks all the rules.

5 COLOR

OX is green! With envy. He's colored green as well. If you have a dark and a light green marker or crayon, use the lighter green color. OX's tongue is pink—but if you don't have pink, red works too.

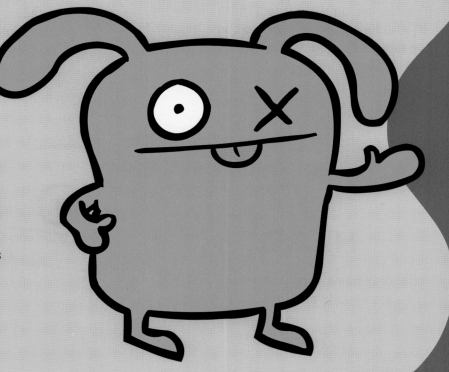

Step 20: Erase me!

What's up with OX's arm? OX often has his hand out . . . either for a free handout or to express his dissatisfaction with pretty much everything. Why is OX so displeased? He's a perfectionist. It would be PERFECT if you could hand over all your stuff and be on your way! Or stay, should you have more.

UGLYDOG™

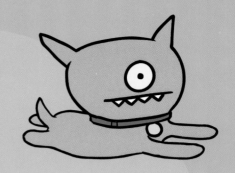

Uglydog doesn't beg, roll over, or sit. (Well, okay, he sits quite a bit.) What he does do is follow you around—to the living room, then to the bedroom, then to the kitchen—all over the place! Uglydog is always there for you.

1 EYE

Uglydog has only one eye. (That's plenty for him!) And he has his eye set on some bones! To help him on his quest, draw a circle (a round one). Then add his pupil. A little dot will do.

2 MOUTH

Uglydog's face looks kinda sorta like Target's. (Are they related? They do have a similar diet.) Uglydog has a straight-ish mouth with four pointy teeth. If you can draw a line with four little upside-down triangles, you've got it!

3 HEAD

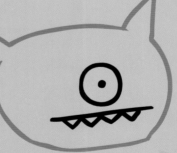

Uglydog's face looks like Target's. (Sorry, Uglydog!)

Uglydog has a very round head, and his ears usually point out at an angle.

4 COLLAR

Uglydog's collar has a small buckle, which is really just two little lines. His dog tag hangs from the center. You can write his name on his dog tag or even draw a little face on it!

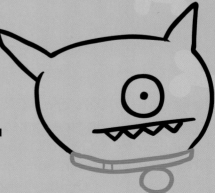

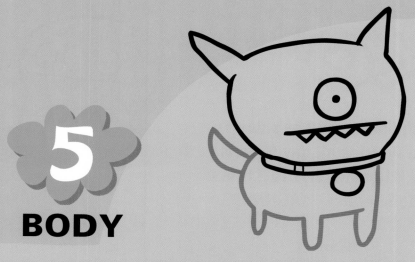

5 BODY

Uglydog has four legs, but you usually see only three, unless he is sitting. His tail should point in the same direction as his right ear. The real trick with Uglydog's body is to draw a straight line from his collar to the point where his front leg curves into the paw. (Some Uglydogs have toes. Some don't seem to.) The rest is up to you, but try not to forget that his round tummy hangs down ever so slightly. Now, about that bone . . .

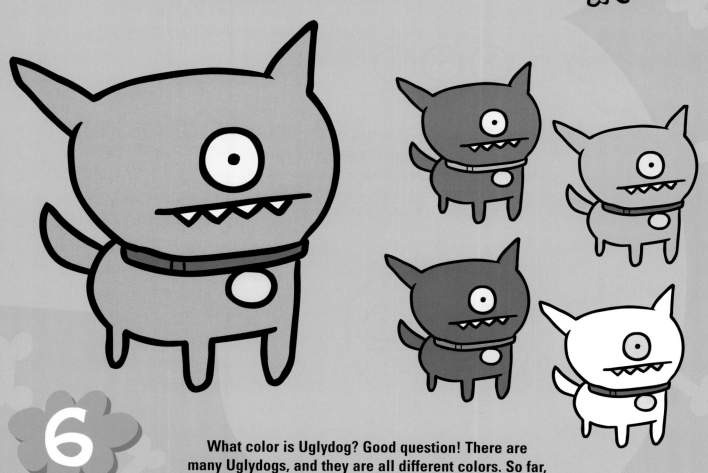

6 COLOR

What color is Uglydog? Good question! There are many Uglydogs, and they are all different colors. So far, we've spotted pink, red, blue, white, and tan. But if you want to make a rainbow-colored Uglydog, go for it!

Cinko™

Cinko is the Uglydoll of the deep. And he's deeply terrified of water! Cinko worries all day long. Is ice scary? What do I do if I get thirsty? Is it true that we're mostly made of water? AAGHHH!

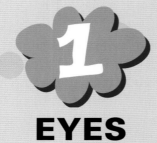

1 EYES

Cinko's three eyes are the exact same size and are lined up in a straight . . . line. All three eyes have little dots in the center.

2 MOUTH

Cinko's tongue is a lot like OX's. So if you're good at drawing OX's mouth, Cinko's will be a breeze. Just draw a straight line right under Cinko's eyes, and add a little tongue sticking out from the center.

CINKO LIST
5 round things
3 eyes
2 much fun
$\frac{1}{2}$ wit

3 HEAD

Cinko's head is mostly round, but it's a little bit flat on top. Cinko's head is shaped like the letter "C" turned on its side.

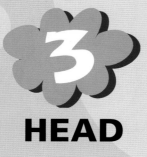

4 BODY

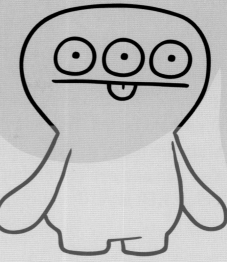

Cinko has legs like Wage's, only a little shorter. Both arms stick out, away from his body, as if he is in a constant state of wonderment.

5 LITTLE CIRCLE THINGS

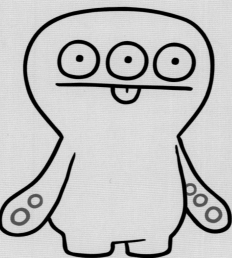

Cinko has five little round circle things on his arms. Sometimes there are two on the left arm and three on the right, and other times there are three on the left and two on the right. There's confusion ALL the time.

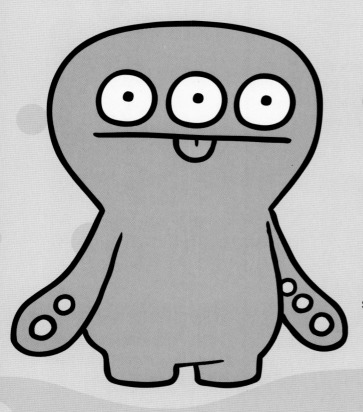

6 COLOR

Cinko is usually the same color as Target. But when he's underwater, Cinko may look a little blue. Blue like sad? Blue like blue. But, yes, he may be a bit sad when underwater, as he's scared silly of anything wet. So if you're using watercolor paints, be gentle! Cinko's tongue is either pink or red, depending on what he has for lunch.

TRAY™

Tray is indeed a girl. Thanks for asking! She'll remember that you did. Tray has three brains—or one brain per lump, as Babo likes to point out. Tray also has one eye per brain and one way to do things: HER way. Or your way. Either way.

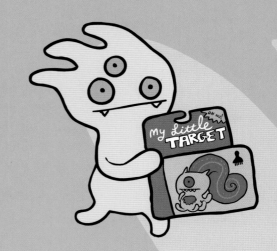

1 EYES

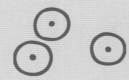

Tray has three eyes. The center eye should always be a little off-center and closer to her right eye.

No thanks

2 MOUTH

Tray's mouth is a very straight line with two little triangle teeth pointing down. Try to line up her teeth with her two side eyes.

Yes!

3 HEAD

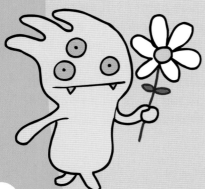

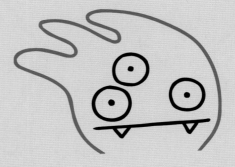

Tray's head has three lumps. The lumps can vary in size a bit, but they should lean back and to the left (if you want them to).

4

BODY

Tray has arms like Cinko—no fingers—but her arms are a little shorter than Cinko's. They reach down to the middle of her body. See how Tray holds that flower? Somehow she's still able to grip pretty much anything, even without fingers. She certainly doesn't need fingers to POINT OUT what's wrong with Babo! Her feet look a lot like Wedgehead's feet—NO FEET! Tray is all legs.

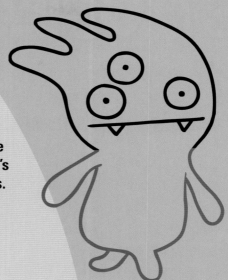

5

COLOR

Tray's body is pink, and her eyes are blue (from all that blueberry pie). Her teeth are a slightly lighter blue, but if you have only one blue, you can use the same color—or make them white. Unless you're drawing on black paper. Then use blue. Unless you're using markers. In that case, give up!

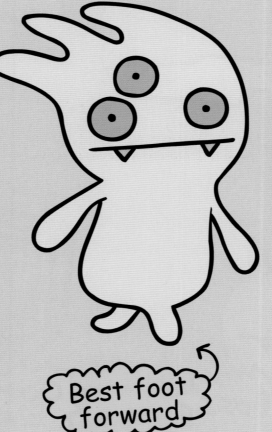

Tray is always on the move

Best foot forward

WHEN THINGS GET UGLY

THINGS! They're everywhere! Let's draw some of the things found in the everyday life of the Uglydolls. Just don't cry over the spilled milk. Unless you really feel like doing so. Then okay.

JUNK MAIL

FLAT TIRE

SPILT MILK

GRUMPY BOSS

COMPUTER CRASH

BUGS

UFO

SHOP

SHOP

Sorry, We're OPEN

SHOP
we're sold out 24-7

FISH

OCTO

MORE THINGS!

Want to draw more things? Wondering what other items the Uglydolls use on their adventures? Well, what do YOU use? Same! Draw the things around you in daily life . . . Trees. Animals. Clouds. You know, those things.

CORNER DELi

HAVE A PRETTY UGLY DAY!

Want to know how to draw the Uglydolls? There's really only one way—YOUR way! Have you ever heard an adult say, "I can only draw a stick figure." Well, if you draw a stick figure, you get a stick figure! You've got the skills. Now show us what you've got. The only hard part about drawing is starting! Stick with it! Get UGLY!

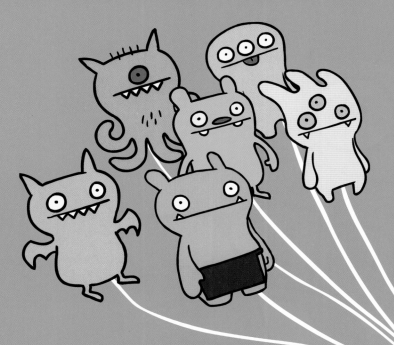

BONUS!!!!

DAVID UGLY'S PRO TIP: Want a really awesome tip? Try this one! Instead of telling everyone what you PLAN on drawing, just draw and SHOW us what you've come up with! Then repeat!

DAVID HORVATH

Top secret: You can make your drawings look uglier than ever before! And you can learn other cool stuff too! How, you ask? Do you have treats? Just kidding—the Uglydolls will tell you even if you don't have treats, because they like you. (Just don't ask Jeero. He doesn't answer questions.) A whole bunch of ugly is headed your way!

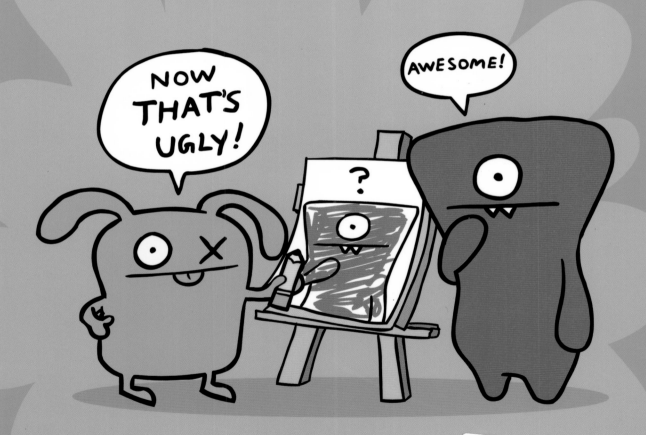

Ages 6+
CATEGORY: Juvenile Nonfiction / Art / Drawing

ISBN – 13: 978-1-56010-991-4
ISBN – 10: 1-56010-991-2

$5.95 US
$7.95 CAN

Walter Foster
www.walterfoster.com

TRADITIONAL
TATTING PATTERNS

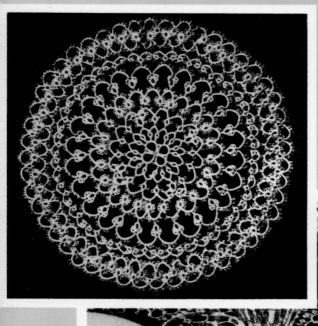

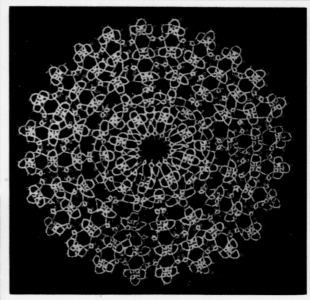

Edited by Rita Weiss